VIA FOLIOS 126

A CENTURY OF SINATRA

A CENTURY OF SINATRA

GAY TALESE & PETE HAMILL IN CONVERSATION

EDITED BY
STANISLAO G. PUGLIESE

BORDIGHERA PRESS

Library of Congress Control Number: 2017959136

Cover Photo:
George Kalinsky

Printed in the United States.

Published by
BORDIGHERA PRESS
John D. Calandra Italian American Institute
25 West 43rd Street, 17th Floor
New York, NY 10036

VIA FOLIOS 126
ISBN 978-1-59954-121-1

TABLE OF CONTENTS

Acknowledgments

It was with some trepidation that I initially agreed to act as co-director for a symposium to commemorate the centenary of Frank Sinatra's birth in 2015. In 1998, I had participated in a major conference devoted to Sinatra at Hofstra University, in collaboration with the Sinatra family. We had planned to bestow an honorary degree on Sinatra but Ol' Blues Eyes had other plans and died in May, just five months before the conference. The 2015 event was conceived as a day-long symposium but morphed into two weeks of lectures, roundtables, film screenings and culminating with a special musical performance, "The Sinatra Future" featuring six Hofstra University music students—Zack Alexander (Class of 2018), Kyle Benaburger (Class of 2016), Christina Cinnamo (Class of 2017), Jaden de Guzman (Class of 2017), Allie Lambraia (Class of 2017), and Ian O'Malley (Class of 2016)—all under the charismatic direction of Professor of Music, conference co-director and irrepressible colleague, Dr. David S. Lalama.

The symposium evolved with the support of Hofstra University President Stuart Rabinowitz, Provost Dr. Gail Simmons, Vice President for University Relations Melissa Connolly and her staff, and Dean Bernard J. Firestone. Additional support came from the Departments of Music and History, the Lawrence Herbert School of Communication and the Hofstra University Honors College. The centenary tribute was organized by the Hofstra University Cultural Center under current director Athelene Collins, former director Natalie Datlof, Jeannine Rinaldi and Carol Mallison.

Friends of the University who contributed to the success of the symposium: the D'Addario Music Appreciation Initiative, the New York Grand Lodge Foundation of the Order Sons of Italy in Amer-

ica, the Tiro a Segno Foundation, the Queensboro UNICO Foundation, Salvatore Mendolia and family, Joseph Corsini and family, the Association of Italian American Educators and its president Cav. Josephine Maietta, the Long Island Regional Chapter of the Italian American Studies Association, Joe and Sal Scognamillo from Patsy's Restaurant in New York City, the Dorothy and Elmer Kirsch Endowment at Hofstra University and Len Triola, who served as consultant for the symposium.

A special thanks goes to John Bohannon, host of "The Jazz Café" on Hofstra University's radio station, WRHU; musician Jerry Bruno (who played with Sinatra); Mark Simone, radio host on WOR-710 AM; Mark Rotella; Professor Shalom Goldman of Middlebury College; musician and author David Finck; musician and arranger Tedd Firth; singer Jane Monheit; journalist and archivist Arnold Jay Smith at New Jersey City University; Debbi Whiting; scholar Will Friewald; Professor John Gennari of the University of Vermont; Joe and Sal Scognamillo of Patsy's Restaurant; author Mark Rotella, Professor Rocco Marinaccio of Manhattan College; journalist Sandy Kenyon at WABC-TV; biographer James Kaplan; Ron Forman, host of "The Sweet Sounds" on WKRB; and Michael Spierman, Artistic Director of the Bronx Opera Company.

Thanks to Dr. Anthony Julian Tamburri, Dean of the John D. Calandra Italian American Institute and editor of Bordighera Press for taking on this volume. A special thanks to Peter Michael Franzese (Hofstra Class of 2000) for his photographs of the evening and George Kalinsky, official photographer of Madison Square Garden for participating in the conversation and granting permission to use his photos.

My thanks to Palgrave Macmillan for permission to reprint an excerpt of my essay "Longing, Loss and Nostalgia" from the first volume of the 1998 conference proceedings.

In the course of editing that volume, our young daughter Giulia (four years old at the time), used to wake up every morning, come down the stairs to the kitchen and ask me to dance with her to Sinatra's music. My mornings have never been so bright. I dedi-

cated that first volume to her in appreciation for those early morning dances and dedicate this volume to her for those precious memories marked by Sinatra's singing.

Longing, Loss, and Nostalgia

Stanislao G. Pugliese

There are almost as many Sinatras as our imaginations may will into existence: the wise-ass street kid from the streets of Hoboken; the vulnerable crooner who made the bobby soxers swoon at the Paramount; the self-destructive moth to the flame of Ava Gardner; the eternal Maggio and the Comeback Kid; the head Rat with rock glass in hand; the original "gangsta" epitomizing cool and a certain way with women; the ferociously proud Italian American; the Chairman of the Board; Ol' Blue Eyes; civil rights spokesperson . . . In short, Sinatra was the palimpsest upon which much of American culture was written in the second half of the twentieth century.

Author, composer, and musicologist Arnold Shaw is only partially correct in his comparison between the original leader of the Rat Pack and Sinatra: "If Humphrey Bogart stands forth as the existential man, viewing life with a sense of detached irony but living with courage within the human condition, Sinatra is the archetype of the romantic man, raging against the human condition," for Sinatra could and did have an ironic streak. Shaw is closer to the mark in focusing in the complex, even paradoxical nature of the Sinatra charisma: Sinatra's appeal as a twentieth-century romantic derives from a set of clashing chords. In the hierarchy of our sex symbols and love gods, he has been the tormented lover, vulnerable

1

as well as triumphant, hurt as well as hurting . . . It is this constant counterpoint of toughness and tenderness that has made Sinatra a magnetic and enigmatic personality. And it was the projection of these polarities in his singing that helped make him the master singer of our time."[1]

Sinatra's appeal rested not just on his masterful singing but on these carefully constructed images and myths. Sinatra was fully conscious of their construction although he was not always sure how much the myths depended on his consciousness of their construction. In classic postmodernist language, he remarked late in life: "Sometimes I think I know what it was all about, and how everything happened. But then I shake my head and wonder. Am I remembering what really happened or what *other* people think happened? Who the hell knows, after a certain point?" And contrary to the cock-sure assertiveness of "My Way," Sinatra at the end of his life was less sure of "his way" than at any time in his life. "Maybe that's what it's all about. Maybe all that happen is, you get older and you know less."[2]

In the arena of images available to us in framing "our" Frank Sinatra, I would here suggest another possible—although admittedly flawed—construction. Sinatra conflated within himself several of the stock characters of the tragicomic art form of *commedia dell'arte*. In some ways Sinatra resembles Arlecchino (Harlequin), the immigrant, with a primitive and simple personality who evolves into a smart, sophisticated character. To survive, Arlecchino must make use of his wits to best the arrogant and greedy characters he encounters. Flanking Arlecchino are the Zanni, poor immigrants, ever hungry, yet shrewd, insolent, masters at the art of *arrangiarsi*

[1] Arnold Shaw, *Sinatra: Twentieth-Century Romantic* (New York: Holt, Rinehart and Winston, 1968) 3.
[2] Pete Hamill, *Why Sinatra Matters* (New York: Little, Brown, 1998) 180.

("arranging" or "systematizing" oneself). In his own dexterous manner, Sinatra, too, exemplified the peasant and immigrant's art of *arrangiarsi*. Brighello (the name comes from *briga*, "to fight") is the first among the Zanni: Cunning and avaricious, he is the trickster who prefers young lovers. And personifying the tragicomic nature of the human condition, the Neapolitan Pulcinella. Agile, nimble, skillful, dexterous, adroit, clever, stoic yet a dreamer, Pulcinella is a victim of melancholy, the enduring disease of the *Mezzogiorno*, the Italian south. Melancholy—not to be confused with depression—can best be described as a pensive sadness or a sober musing that occasionally gives way to despair. And just as Pulcinella's *coppolone* (sugar loaf hat) came to symbolize his character, Sinatra's snap-brimmed hats, worn at various angles to indicate his mood, came to symbolize an American icon.

There is a certain character trait that is common in these personalities of the *commedia dell'arte*: they are always attempting to create and control anarchy at the same time.

Much has been written of Sinatra's paternal Sicilian origins (his mother, Dolly, was from Genoa, with an entirely different set of cultural codes and mores). On the surface, any outside observer would have thought that it was his father, Marty, who must have been from the "reserved" north of Italy and the volcanic Dolly possessing the Sicilian blood. Yet that was not the case. Southern Italians are by nature reticent and not prone to public displays of wrath or fury. Although notorious in trying to protect his privacy, Sinatra often betrayed the cult of *omertá*, the ancient Sicilian code that demands silence before strangers. No information—no matter how seemingly obvious or trivial—is to be divulged. (For example: The polished practitioner of *omertá* can and will deny knowledge of the town's fountain when it can be seen and heard gurgling behind

his back.) Sinatra's betrayal of *omertá* is there on every record and radio broadcast.

In many ways, he represented the dilemma of the emigrant, torn from an impoverished, rural society that was paradoxically both intensely Catholic and yet deeply pagan, bereft of the benefits of modernity. Author and scholar Robert Viscusi has poignantly described the trauma inflicted on those who left Italy in the late nineteenth and early twentieth centuries: "A whole nation walked out of the middle ages, slept in the ocean, and awakened in New York in the twentieth century."[3] Under such conditions, it is not to be wondered that nostalgia is the immigrant's disease. First coined by a Swiss physician in the late seventeenth century, the word "nostalgia" is derived from the Greek *nostos*, meaning "to return home," and *algia*, "a painful condition"—hence, "a painful desire to return home." *Webster's* suggests "a wistful or excessively sentimental, sometimes abnormal yearning for return to some past period or irrevocable condition." The etymology of the word can help orient us in that bewildering topography of the mind where memory and the present intersect. Where exactly is the "home" for which we are homesick? Is it some small village in rural Italy, or is it rather a highly personal, idiosyncratic conceit held together by memory, longing, pain, and loss? In the architecture of memory, "home" is truly where the heart is and remembers. As such, is it constructed both individually (in memory) and collectively (recalling those past experiences with others and thereby reinforcing their particular characteristics).

Nostalgia is based on personal history and experience: One cannot be nostalgic about the Roman Empire or the medieval Crusades. In the nostalgic imagination, certain aspects of life are privi-

[3] Robert Viscusi, *Astoria* (Toronto: Guernica, 1996) 22.

leged: the family, nature (usually its abundance), childhood and youth, first loves. Yet even painful experiences can pass into the realm of precious nostalgia, as when Italian Americans of the post-1945 immigration recount their suffering during World War II. It soon becomes obvious that nostalgia is one of many strategies available to the individual and the immigrant in constructing an identity.

Nostalgia is a yearning for the past in order to rectify past and current perceived wrongs; a desire to embrace myths that are capable of regenerating society or the self. Nostalgia questions and challenges the Enlightenment tradition of scientific-technological rationality and is a manifestation of the crisis of modern individualism. This phenomenon of being trapped in time is undoubtedly familiar to all students of immigration. An Italian scholar has called nostalgia "an ambiguous emotion" and focused on its dual components of memory and desire. Nostalgia is a rebellion, a movement of transgression against the limitations imposed physically by time and space; it is an attempt to push the parameters of possibility and impossibility.[4] This dialectic of presence and absence reaches pathological dimensions when that which is absent is more real than that which is before us; when our idealized image of the past, admittedly necessary for both individuals and societies, prevents us from living in the present. The fortunate immigrant passes through a mourning period that is also a process of liberation, so that there can be a sense of belonging to the new culture without giving up one's cultural heritage. The unfortunate immigrant is trapped by memory.

[4] On nostalgia, see Stanley L. Olinick, "Nostalgia and Transference," *Contemporary Psychoanalysis* 28.2 (April 1992): 195-98; Guglielmo Bellelli, "Une emotione ambigue: la nostalgie," in *Cahiers Internationaux de Psychologie Social* 11 (September 1991): 59-76; and Pier M. Masciangelo, "La nostalgia: una dimension de la psiquica," in *Revista de Psicoanalisis*, 47.3 (May-June 1990): 546-557.

Nostalgia, then, is a complex dialogue of the self, but also a dialogue that must engage others in the construction of an ideal past. In an age of forced mobility, uprootedness, discontinuity, and rupture, nostalgia seeks to mend the torn fabric of the fragile psyche. It may also be a rationalization and justification for an ancient transgression—the abandonment, and therefore the betrayal, of the family and the *paese*.

The literary critic Frederic Jameson, writing in regard to the cultural theorist Walter Benjamin, perceptively observed that "if nostalgia as a political motivation is most frequently associated with fascism, there is no reason why a nostalgia *conscious of itself*, a lucid and remorseless dissatisfaction with the present on the grounds of some remembered plenitude, cannot furnish a revolutionary stimulus as any other."[5]

Sinatra was caught in the double bind confronted by all immigrants to America: The necessity of assimilating into American culture while retaining a distinct ancestral identity. As the late anthropologist Thomas Belmonte has written, "The predicament of the Italian-American was a predicament of loss. How to relinquish the medieval mind, with its sensuousness, its wisdom, its religious devotions, its oaths, its belief in envy-motivated magic and the power of incantation? How to become a 'modern American' and condemn the old country's traditions of blood feud and vengeance? How to downplay its emphasis on virginal chastity and maternal sacrifice? . . . America liberates. But when it liberates the Italian-American, it creates a self that is painfully divided."[6]

[5] Frederic Jameson, "Walter Benjamin, or Nostalgia," in *Salamagundi* 10-11 (Fall-Winter 1969-1970) 68.
[6] Thomas Belmonte, "The Contradictions of Italian-American Identity: An Anthropologist's Personal View," in *The Italian American Heritage: A Companion to*

If history is a house built on memory, nostalgia is the compli-
cated and often painful blueprint for its construction.

The latest census figures indicate that perhaps more than 20
million Americans identify themselves as Italian Americans. Yet the
overwhelming majority are the grandchildren and great-
grandchildren of immigrants, and their ties to Italian-American
culture are tenuous at best. If Italian-American culture runs the risk
of degenerating into a culture of nostalgia, it also is in danger of
losing its pathos to bathos.

> **pathos** *n*. [Gr. *pathos*, suffering, disease, feeling . . . to suffer] 1.
> [Rare] suffering. 2. the quality in something experienced or ob-
> served which arouses feelings of pity, sorrow, sympathy, and
> compassion. Not to be confused with the common usage of pa-
> thetic which in reality denotes bathos which is a false or over-
> wrought pathos that is absurd in its effect. Poignant: a sentiment
> that is keenly felt, often to the point of being sharply painful.[7]

Sinatra managed, for most of his career, to sing on the right
side of the fine line between pathos and bathos. The quality of pa-
thos came from longing and loneliness. Hamill comes closest to the
mark in arguing that "Sinatra had only one basic subject: loneli-
ness."[8] Yet that is only part of the whole, for that loneliness was
always accompanied by pathos, melancholy, and nostalgia for
something (not just a woman) irreparably lost. In his embrace of
longing, loss, and nostalgia, Sinatra gave voice to the immigrant
myth. "The core of the immigration myth," writes Hamill, "is this:

Literature and the Arts, Pellegrino D'Acierno, ed. (New York: Garland, 1999) 15 -
16.

[7] *Webster's New World Dictionary* 1980, 1041.

[8] Hamill, *Why Sinatra Matters*, 69.

it was about the way people overcame misery, how they found their consolations, and, in the end, how they redeemed America in a time when America believed it was not in need of redemption."[9] Sinatra was one of the "agents of consolation": Although he wasn't as successful, the average Italian American could look to Sinatra as one of "us" who had climbed to the top without sacrificing the ethos and mores of the *via vecchia* (old way).

The middle third of the twentieth century was a momentous time for both Sinatra and Italian Americans. Sinatra's name was synonymous with the popular music of twentieth-century America; another Italian name (Joe DiMaggio) was synonymous with the nation's pastime, and still another Italian name (Fiorello LaGuardia) was considered to be the finest mayor in the history of New York City.

Immigrants from the Italian south, who never considered themselves Italians while in Italy, rediscovered a shared cultural history in America. If Machiavelli's *The Prince* (1532) argued that the state could be a work of art (or artifice), Baldassare Castiglione's Renaissance manual, *The Book of the Courtier* (1528), held that the self is a work of art. It was Castiglione who coined the term *sprezzatura* as the art of making the difficult appear easy. DiMaggio epitomized this on the ball field while Sinatra exemplified *sprez-zatura* on stage and in the recording studio. Although both were meticulous craftsmen who would work hours to perfect their craft, the appearance was one of unforced and spontaneous brilliance.

Pete Hamill's *Why Sinatra Matters* (1998)—quickly recognized as the best thing written in the immediate wake of Sinatra's death—opens on a rainy, 1970 New York midnight at P. J. Clarke's saloon. Sinatra is holding court at a table attended by Ha-

[9] Ibid., 51.

mill, the disc jockey William B. Williams, the sportswriter Jimmy Cannon, the restaurateur Jilly Rizzo, and Danny Lavezzo, manager of the bar. The conversation eventually turns into an argument over the relative greatness of Ernest Hemingway and F. Scott Fitzgerald. Cannon champions Hemingway but Sinatra—revealingly —argues in favor of Fitzgerald. Like his hero, Jay Gatsby, Sinatra "believed in the green light, the orgiastic future that year by year recedes before us." It was that longing for a lost future that so permeated his music and life that gave it an essential quality of longing, loss, and nostalgia.

At the end, with Ava Gardner and Dean Martin and the others of the Rat Pack all gone, Sinatra was alone in facing the tyranny of nostalgia: "So we beat on, boats against the current, borne back ceaselessly into the past." Our only consolation is that, in the end, the music remains—Sinatra's siren song of nostalgia and longing, memory and desire.

A Century of Sinatra

Gay Talese & Pete Hamill in Conversation

HOFSTRA UNIVERSITY
Tuesday, November 10, 2015

STANISLAO G. PUGLIESE: Ladies and gentlemen, students, musicians, friends and family: good evening. On behalf of my colleague and co-director Dr. David Lalama, the Departments of History and Music, the Hofstra Cultural Center, the University administration, faculty and students, welcome to the opening of our six-day celebration of Frank Sinatra's centenary. My name is Stan Pugliese, Professor of History and the Queensboro Unico Distinguished Professor of Italian and Italian American Studies here at Hofstra.

Let's begin by formally introducing our speakers. Gay Talese is a best-selling author who has written a dozen books and hundreds of essays. He was a reporter for *The New York Times* from 1956 to 1965, and since then he has written for *Esquire*, *The New Yorker*, *Harper's Magazine* and many other national publications. Gay Talese was born in Ocean City, New Jersey, and currently lives in New York. His 1966 groundbreaking article, "Frank Sinatra Has a Cold," was named the "Best Story *Esquire* Ever Published," and he is acknowledged as the creator and the progenitor of what Tom Wolfe later called the "New Journalism." Among his noted books are *The Kingdom and the Power* about *The New York Times*; *Honor Thy Father*, about the Bonanno crime family; *Thy Neighbor's Wife*, about the sexual revolution in the United States, and my personal favorite, *Unto the Sons*, a memoir about the history of his family from Calabria, Italy. Another memoir, *A Writer's Life*, was published in 2006, and a collection of his sports writing, which is how he began his journalistic career, *Silent Season of a Hero* about Joe DiMaggio, was published in 2010. Welcome Gay Talese!

13

GAY TALESE: Thank you.

SGP: Pete Hamill is an American journalist, novelist, essayist, editor, and educator. He is a distinguished writer in residence at New York University, and is perhaps best known for his career as a New York City journalist. Pete Hamill was a columnist and editor for the *New York Post*, and the *New York Daily News*. He has also written for magazines such as *New York Magazine*, *The New Yorker*, *Rolling Stones* and *Esquire*. In 1994 he published a best-selling memoir, *A Drinking Life*. He is the recipient of the Ernie Pyle Lifetime Achievement Award from the National Society of Newspaper Columnists in 2005. In 2014, he received the George Polk Career Award, and in 1998, he published his extraordinary book, *Why Sinatra Matters*, immediately after Sinatra's death. It is universally considered one of the best things ever written about Frank Sinatra and is now reissued as a new edition. Welcome Pete Hamill!

PETE HAMILL: Thank you.

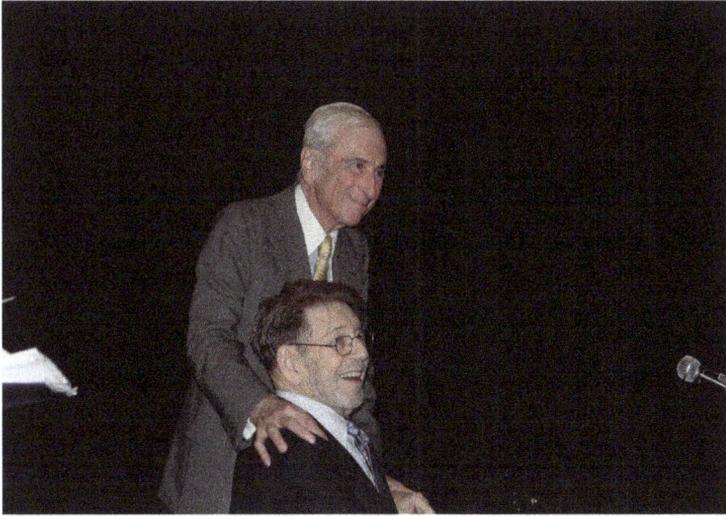

Gay Talese and Pete Hamill

Photo: Peter Michael Franzese

SGP: This evening we are going to be talking about immigration, culture, politics, but this is not the Republican debate.

[laughter]

We are going to discuss these things in a different way, because it seems to me, from the readings of these two distinguished writers, that these themes of immigration and culture and politics run through the life of Sinatra both as he lived his life and as he was received by the American public. Gay Talese, as I mentioned, was born in Ocean City, New Jersey. His father was a master tailor who had emigrated from Calabria. But in your house, as you mentioned in your memoir, *Unto the Sons*, your father insisted on listening to the operas of Puccini and Verdi on the Victrola and later on the radio. So what did it mean to you as a young boy growing up in Ocean City, which was not Mulberry Street or one of the meccas of Little Italy? What did it mean to you to listen to Frank Sinatra on the radio?

GAY TALESE: Well, in a way it was rebellion against my father's classical education in music at least. But, what mattered to me and what changed my life more than my father and mother in a way was the radio. I was born in 1932, and in 1942, Italy, my father's country was at war with America, and my mother's people come from the same part of Calabria as my father. So I was at the age of 10 or 11 in a small town going to a parochial school, a very small parish in a Protestant town. I wasn't sure because my father had two brothers in the Italian army. I was telling Pete this before, but I'll repeat it with a little more elaboration now. My father came to America in 1921 and became an American citizen in 1928. He was

16

the only one from his family who came to America. His brothers and his uncles and others, and his mother, all stayed in Italy. In World War II, his younger brothers were in Mussolini's Army. I was going to a little school at a church in Ocean City and we'd go to the movies on Saturday with my American classmates. I'd see the war news, and the Italians were of course always being captured, defeated, bombed, including my father's village, Maida.

I would see these dusty old Italian soldiers in a cart being carried away to some prison camp, and I would think of them as my father's brothers, because I had pictures of my father's brothers in Mussolini's uniform on the bureau of my father's bedroom, and I never knew in the beginning whether I was on the Italian side of the war or the American side of the war. I was such a fractured person.

My father and mother were store keepers. My mother had a dress shop and my father had a tailor shop, as was said. And during the daytime, they were pro-American. In our little town on the main street of the town, American flags were in front of every shop, our tailor shop, next to it was a shoe shop. There was a haberdashery down the street. There was a food market. Everybody was pro-American. Especially people my age, or some of you, might remember World War II was a time of great patriotism, particularly in small towns, where there wasn't much mixture of anything except the dominant society, and that was white Protestant in my town.

So, being confused about my own right to be an American, because I wasn't sure where I belonged, one of the things that changed my life was listening to the Lucky Strike Hit Parade on the radio, and Sinatra was then emerging as a real voice. And my father, as was said, was playing Italian opera when I came home from

17

school. It was only opera on the record player, but I was almost furtively singing with the radio. Not singing along, but listening to Sinatra sing, and as Sinatra became increasingly prominent, accepted by the larger American audience, from coast to coast, and became accepted, more than any Italian-American of my time, as a success story. The other people who were in the news of my generation with Italian names were all gangsters: Lucky Luciano and all the rest. During the whole of World War II, they were in the news all the time, with those Italian names, but always with organized crime.[1] It's true that there was some sports heroes. Joe DiMaggio was of the same generation, but DiMaggio was a solitary figure, a singular figure, a great athlete on the field. Off the field except for his romance with Marilyn Monroe, DiMaggio was a very interior man.

I read a book once about DiMaggio, and it said that he never had dinner with the people who played on the great Yankee teams with him. DiMaggio was not a person that would get involved with the politics of the time. He was just a solitary star on the field. Sinatra was not a solitary star. He was a pervasive presence in our country and an American success. And as Sinatra became more and more accepted by the larger American population, appreciators of not only his music but his political certitude and his driving force to be democratic in the way he lived, embracing in his orchestra and people that he associated with, Jews and blacks and other people. He was a very, very inclusive man. A fighter for the democratic principles that all of us live by or we think we do; but

[1] On the common negative stereotypes rampant at the time, see *Anti-Italianism: Essays on a Prejudice*, William J. Connell and Fred Gardaphé, eds. (New York: Palgrave Macmillan Italian & Italian American Studies Series, 2010).

there's such hypocrisy and mixed up with all this as we know. I believe that what Sinatra did for me as a teenage boy was make me feel more an American. He helped me to feel that I was an American, not an Italian, not an immigrant's son, not a tailor's son, but a real American.

I never was able to tell him that. I never was able to have the opportunity to say that until, such as tonight, recently, because I wasn't aware of it until years later. And so, only about a month ago I happened to meet Nancy Sinatra at the Paley Center for Media in New York City. There was an occasion when she was there and other people who knew Sinatra were there, and I was asked to be part of it, and I told her that her father had made me feel American, and she said, "Oh, that's the nicest story I ever heard." And I was so glad I had an audience. At least through her I could tell her late father how much he meant to me.

[applause]

SGP: Pete Hamill, you're of the same generation, from the other side of the ethnic tracks, from an Irish community. At that time Bing Crosby was the great crooner on the radio. So, what was your introduction to Frank Sinatra? What did it mean for an Irish kid to be listening to an Italian crooner, in Brooklyn, in the 1940s?

PETE HAMILL: Well, my parents were immigrants too, from Northern Ireland. They didn't come together to America, they met in New York. My mother—with perfect Irish timing—landed the day the stock market crashed in 1929.

[laughter]

And she ended up with a job at Wanamaker's Department Store, then other places. But when they met each other, my father had lost a leg playing soccer. He had his left leg smashed. He was taken to Kings County Hospital in Brooklyn years before penicillin, and by the morning, gangrene had set in, and here came the guy with the saw. They met at a dance hall that's still there, called Prospect Hall. You might see the funny commercials every once in a while on Prospect Avenue, "Hey, this is Prospect Hall." And she noticed him sitting by himself over against a wall while his friends all danced with women all over the place, and she walked over and said, "Let's dance," and he said, "I can't dance," and she said, "Ah, neither can I."

[laughter]

PH: And she took his hand and walked him into the rest of his life. But there they were. They worked and they worked and they worked and they worked. My mother worked in a box office of an RKO Theater. My father worked first in a place making bombsights and Bush Terminal Park in Brooklyn, and later in a place that made fluorescent lights, which I never want to see again as long as I lived. They turned everybody in the kitchen blue.

[laughter]

We lived in a tenement that had hot water but no heat. So I loved doing the dishes to warm up. And our life really began as Americans when Mrs. Caputo came across the hall and taught my mother how to make the sauce; that was the beginning of our lives.

It's no accident that at least two of my brothers and my sister all married Italian guys, it had to be the food. [chuckle]

SGP: I don't know if you know this book that just came out by Paul Moses called *An Unlikely Union: The Love-Hate Story of New York's Irish and Italians.*[2]

PH: I have it; I haven't read it yet.

SGP: I mentioned it to a colleague of mine at Hofstra University, Patricia Navarra, and she said, "I have 32 Irish-American cousins, 31 of them married Italians!"

[laughter]

PH: I believe it.

SGP: The 32nd one, she said, the one who married an Irish guy, got divorced.

[laughter]

I said to myself, "I have to tell this story to Pete Hamill."

PH: That figures too. [chuckle]

GT: Well, my wife is half Irish and we've had 57 years of marriage, so something's working.

[2] (New York: New York University Press, 2015).

PH: Yeah.

SGP: [gesturing toward front row of audience]: Our honored guest, Nan Talese, editor and publisher at Doubleday Books.

[applause]

PH: So anyway, my mother worked during the day and then later worked at a box office in the theater starting at 5 o'clock. All day long, she would listen to WNEW, either Martin Block, or one of the other stations, one of the other programs, and therefore got more than Bing Crosby. Crosby, by the way, was in many ways wonderful in what he did, but he was not urban. Along came Sinatra, and I was a boy, but I could hear it and say, "That's more like the world I live in than the guy from Walla Walla, Washington."

SGP: This is an extraordinary quote from Pete's book, "There was a tension in Sinatra, an anxiety that we were too young to name but old enough to feel."

PH: Yes.

SGP: This is the urban experience of the immigrant. Pete writes that Sinatra became inseparable from the most powerful of all American myths: the myth of the immigrant. Myth used here in the sense that not that it's not true, but myth in the sense of the way myth is originally from the Greeks and the Romans: a story that tells a larger truth. That is what I find extraordinary.

PH: Yeah. And which in almost every case in a city like New York and in other parts of the country, the immigrants brought gifts to us. They brought food, they brought music, popular music. Because, remember, they were not people who had lived at La Scala to watch opera. They didn't hear opera until they got to New York, and could hear it in a window in August because nobody had air conditioning.

[laughter]

An evening for John Lindsay, Madison Square Garden, October 11, 1969.

From the Lens of George Kalinsky

But they gave us these amazing gifts while we were getting to know each other. And we had street games, stickball and other games, softball in the park, Prospect Park, that also mixed us altogether. In our group, I had Vito Pinto and Mike McAleavey, in the same group. And when we all went away into the services in the 1950s, and earned the GI Bill, we came out and we were able to have lives that were not identical to what our fathers did. My father worked in a factory. I ended up writing for newspapers. Because the gifts that the GI Bill gave me, I was able to sit at work and hear artists speak about composition and craft and the importance of trying to be excellent. And at the same time, there were no speeches about America the beautiful or any of that stuff. There wasn't that at all. It was saying, "If you work hard, and obey most of the rules, you're gonna do okay in America. You'll be okay, don't worry about it." And that was a promise that was kept.

SGP: You have this extraordinary idea in the book where you say that Sinatra's gift was to remind Americans what we were about, to redeem America at a moment when America didn't think it needed redemption.[3] Regarding the situation today, I was thinking about this line when I recently read a report on how mortality rates for middle age white people are rising when mortality rates for everyone else are going down. What does Sinatra say to us today, when perhaps the social contract is not what it used to be? It's not like I can say to these young people here in the audience and in my classes, "Don't worry. You're going to graduate from Hofstra, work

[3] "The core of the immigration myth is this: it was about the way people overcame misery, how they found their consolations, and, in the end, how they redeemed America in a time when America believed it was not in need of redemption." Pete Hamill, *Why Sinatra Matters*, (New York: Little, Brown, 1998), p. 51.

for the same organization or corporation for 40 years, and you're going to retire with a gold watch and a good pension and you'll live happily ever after." The idea that if you come to America, you work hard, you play by the rules, you could become a success. That seems to me to become more difficult, both for immigrants and for Americans who have been here a while. So what can Sinatra say to these young people, like our students and our musicians, what does Sinatra say to them today?

GT: I think anybody who is skilled enough to be a musician is in an occupation that's close to angelic, because musicians are part of a world art. If you can play an instrument or sing well enough to be in a chorus, or solo, you can communicate. Even if you don't have a facility with a singular language, you can communicate to the world. Once, about four or five years ago, I was in Argentina, interviewing, traveling around with an opera singer for a magazine piece. And while I was in Argentina, I heard the great conductor and musician, Daniel Barenboim, who had an orchestra made up of Palestinians, a young Israeli orchestra, and they were just inspiring to listen to. But on the political side, I thought, "If everybody in the world could play an instrument or participate in music in some way, we would have no war."

[applause]

GT: And so Sinatra, through his music in front of orchestras of all kinds of people, or friends, whether it's Sammy Davis and Joey Bishop, or whoever, he was living an egalitarian society within a family relationship, living a democratic way, having associated personally with so many people from so many different backgrounds. Outside of music, with the possible exception of

26

journalism—which Pete and I are emeritus figures in—I don't know that there are opportunities to associate on a personal level with people whose backgrounds, whose religions, whose color is different from your own. When they talk about, as they started about 30 years ago, about diversity, diversity, diversity, it's really an important thing, and just if we get back to journalism, away from music, just briefly, because I know more about journalism than I do about music, obviously. But journalism allows people, like Pete Hamill and me, both of us the sons from an immigrant background, to work in the English language. Now for Pete Hamill, the Irish people have a great tradition as writers, and Pete Hamill's not the first great Irish writer. Believe me, they have a lot of writers. Not so . . .

PH: It's the weather.

[laughter]

GT: Not so me. Because the Italian people did not come to this country as some people did, speaking the language; we had to learn it. Also, most of the Italian people, like me and all the other Italian names I know, whether they're a Sinatra or Coppola or Scorsese or Lady Gaga, they're all from Southern Italy. Southern Italy is a largely illiterate part of the nation. No offense, believe me, but it's true. Because the people from south of Naples to Sicily, through decades and even centuries were almost in a feudal society, until the beginning of World War II, or to the end of World War II, and they were dominated by a kind of severity of the Bourbon Catholic church, which encouraged illiteracy, because to be literate was to challenge the teaching of the language of religion as imposed upon them by the Vatican. And so we Italian-Americans, we had the

sense of song, whether it's opera or street singing, but not the written word, unlike the Irish or the Jews. The word, the Italians did not have the word. It wasn't in our culture, because our culture being insular, being from villages and mountains. We were taught to keep secrets.

SGP: The Italian concept of *omertà*.

GT: *Omertà* didn't apply only to the Mafia, it applied to everybody, "Don't tell tales about your family. Don't talk about . . . " Well, if you can't talk about who you were, who you come from, you can't really write very much. The Irish wrote, whether it's Pete Hamill or James Joyce, they wrote about what they know, they wrote freely. The Italians got it through song, instead of producing novelists, and Pete Hamill's a novelist as well as you know all the other stuff. The Italians didn't have novelists, except those who could write about the Mafia, which was a selling subject, such as Mario Puzo.[4] My cousin Nick Pileggi and I made most of our money writing about the Mafia. Believe it—it's true. But how else could we do it, in our language, when we didn't have in our origins, a love of language. It was through song that we communicated; Tony Bennett, Frank Sinatra, Dean Martin, Frankie Laine, all these people, where instead of writing short stories or novels or writing plays, they were singing songs. They were telling their stories through song.[5]

[4] Before the commercial success of *The Godfather* (1969), Puzo had written two critically acclaimed books, *The Dark Arena* (New York, Random House, 1955) about the postwar American occupation of Germany, and *The Fortunate Pilgrim* (New York: Atheneum, 1965) about growing up in New York City's Hell's Kitchen.

[5] See Mark Rotella, *Amore: The Story of Italian American Song* (New York:

So this is all I want to say about music. Wish I were part of it. But it is a great way to cross over the restrictions of sameness, of singularity of thought, of a similarity in religion or color. It transcends everything, music does. And Sinatra was the epitome of this, as the personification of the pluralistic society man, a man who came from a background no different from mine. His father was a fireman, only because the mother pushed him into being a fireman. He was a fire lieutenant or captain. And his mother was a bit of an operator in political life, unlike most Italians. So Frank Sinatra chose the right thing. I don't know if he would have made it as a writer like Pete Hamill, or even as me, but he certainly made it as a singer, and he made it as a singer in a way that few singers could emulate him really, or be on his level. He was really a special talent. As Pete, who knows him really better than me, Pete knows Frank Sinatra better than I do. I wrote about him from afar. Pete, tell us how you met Sinatra.

PH: I was in Las Vegas for a fight of some kind . . .

GT: You remember the fight?

PH: A prizefight I don't remember.

GT: Las Vegas, it had to be a heavyweight fight.

PH: I'll remember tonight around 1:30 in the morning.

[laughter]

Farrar, Straus and Giroux, 2010).

GT: Some fight. Maybe Floyd Patterson fight?

PH: It might've been; it might have been. Yeah, before I could take my jacket off, the fight was over.

[laughter]

GT: Yeah. That was it. That was fun, Sonny Liston.

PH: But anyway, somebody . . . Jimmy Cannon, the sports columnist, who was a friend of Sinatra, and like Sinatra he was an insomniac. So he was a big reader. He didn't drink or anything, Cannon, but he had retired with the title as I did later. And he said, "Hey, Pete . . . " And I went over and sat down and was introduced to Sinatra. And he was very polite; unlike the reputation that he had knocked out Lee Mortimer, the world's worst gossip columnist or something. He was friendly, welcoming, and I never saw the fierce side of Sinatra in the years that came. I never saw that. Now, whether he . . .

GT: How did you see him a second time? After the fight did you see him again?

PH: Yeah. Again it was in Vegas. I never saw him in California, I always saw him in New York. And after the second time then when he came to New York a few months later, he called up and said, "Did you eat yet?" [chuckle]

GT: Okay. So he had your phone number?

PH: Yes, he did.

GT: Wow.

PH: And I had his if I wanted to call him for something.

GT: Really? And where did you go? Where'd you eat?

PH: We went to Patsy's.[6]

GT: Wow.

PH: Of course.

[chuckle]

GT: Wow. Do you remember who was with him?

PH: Jilly was there.

GT: Jilly and his wife?

PH: Jilly Rizzo, who later terrified my two little girls when they were five and seven. They met Jilly Rizzo and wanted to run. [chuckle] And disk jockey William B. Williams was there and a couple of others.

GT: Jimmy Cannon there?

[6] See the reminiscences of Joe Scognamillo and Sal Scognamillo, father and son owners in "Sinatra at the Table: Scenes From Patsy's Restaurant," in *Frank Sinatra: History, Identity and Italian American Culture*, edited by Stanislao G. Pugliese, (New York: Palgrave Macmillan, 2004), pp. 119-126.

PH: Oh, Cannon was there. Yeah. We ended up the week later at PJ Clarke's, which he liked too. Sinatra happened to like the urinals at PJ Clarke's.

GT: With the ice in the bottom?

PH: Somebody once said they looked like stalled showers for Toulouse-Lautrec.

[laughter]

They were like this height. [gestures] It was a grand . . .

SGP: Pete's book opens up with a special scene. It's January 1970 in PJ Clarke's Saloon. Around the table there's Sinatra, Pete, Jimmy Cannon, and Jilly Rizzo and . . .

PH: Daniel Lavezzo.

SGP: And the topic of discussion is, "Who's the better writer, Ernest Hemingway or F. Scott Fitzgerald?" What was it like to be in that conversation?

PH: Well, somebody says, "I like Fitzgerald more than Hemingway." And Jilly Rizzo says, "Me too, she can really sing."

[laughter]

SGP: But what's fascinating is that you would think that Sinatra would have championed Hemingway, instead Sinatra's favorite writer was F. Scott Fitzgerald. And Pete has this brilliant insight of

Sinatra as Gatsby. It's extraordinary, in the sense that both of them, both Gay's essay, "Frank Sinatra Has a Cold" and Pete's book have to deal with this kind of conundrum, which is that, as public as Sinatra was you could never really get to the essence of Sinatra.

PH: Yeah.

SGP: And so I was thinking about this, it's almost like Orson Welles's Citizen Kane. Then the question becomes, "What was Sinatra's Rosebud?" And Pete, I think, and Gay too, in the sense that they both write that as public a person as he was, fundamentally, Sinatra's subject was loneliness. In spite of the fact that he was surrounded by people until 3 or 4 o'clock in the morning, he was a lonely man. Perhaps it was because he was an only child? But, that seems to come across in both of your writings.

PH: Yeah. And by definition he became a great vocalist about loneliness. Again, I have talked about this in the past, but one of the unique things about Sinatra is he started off with a primarily female audience, and ended up with a primarily male audience, to whom it was always 2 o'clock in the morning, and they were there alone at the bar and had to go home. I think he understood that in a way that certain kinds of blues singers understood, male anguish, which involves loneliness or being forsaken. And to approach it with a kind of stoic streak that said, "It's quarter to 3:00, there's no one in the place, except you and me." But he's not saying, "Pity me," he's saying, "Give me a drink," and then heading out, "Don't worry about me, I'll get along." There's a thing to the choice of the music.

GT: "And I'll do it my way."

PH: Yeah. Yeah. Yeah. Exactly.

SGP: But that only happened after the whole full, the whole scenario with . . .

PH: With Ava Gardner.

SGP: People talk and marvel about Madonna, how she reinvents herself every decade, but Frank Sinatra did it much earlier. He starts as this skinny kid behind the microphone with the bobby-soxers and then he evolved but that evolution only comes with having lived life and through suffering. It seemed like every decade he was like almost a different person, until he matures into the "Chairman of the Board." What is really extraordinary is the way he could reinvent himself.

PH: Yeah. For a whole life, not just two weeks of fame. He became part of the soundtrack of four or five generations. Part of the soundtrack. I hear certain music out of nowhere and I remember where I was, where I lived. Was I playing ball at night or. . . Oh, I don't know. But I can create the details of my own autobiography by listening to him, and I think that's a kind of thing that hasn't happened yet with other kinds of music. He also had the Great American Songbook. If you got Rodgers and Hart, and Cole Porter, and Arthur Schwartz, and people like that, all of that, those really first-class people; if that's who your writers are, you're gonna find things in there that Russ Columbo didn't find.

GT: Yeah.

SGP: How about this idea: both of you write about this. That

Sinatra in a certain sense was a paradoxical figure, in the sense that at the very same time he wanted to be both, as we say, a *paesano* and a *padrone* at the same time.[7] Gay, you have this scene in "Frank Sinatra Has a Cold" where they're in the bar, and you think that you are witnessing two different things simultaneously: Sinatra the swinger and Sinatra the *padrone*. I wrote about it as Sinatra wanted to be the *paesano*, in other words everyone's friend, but at the same time he wanted to be the *padrone*, the guy who's sitting at the head of the table who takes care of the check, who takes care of everybody. I wrote about this after our first Hofstra conference on Sinatra, that you can not be both the *paesano* and the *padrone*. It's not possible. If you're the *padrone*, people deal with you a certain way; if you're a *paesano*, people deal with you a different way. I think the fundamental conflict in Sinatra was that he wanted to be both at the same time.

[7] Roughly, "friend" (or literally, "one from the same town") and "boss" respectively.

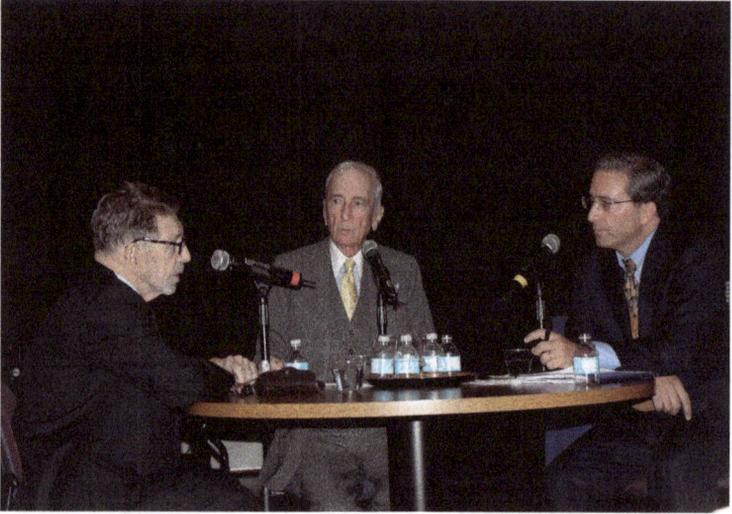

Gay Talese and Pete Hamill in conversation
with Stanislao Pugliese

Photo: Peter Michael Franzese

GT: I'm not sure he wanted to be much of a *paesano*. I think he wanted to be liked by all classes of people, people of all means, people of strength and people of weakness. But I thought he had a prideful sense of self, a singularity about his nature, confidence in his talent, even though he didn't always succeed. As we know, he had his setback from which he returned triumphant. But I don't think Sinatra ever saw himself as a lowly figure, a dependent person. He got tremendous confidence, I think, from being the son of that mother who's really like the Catherine de Medici of Hoboken.

[laughter]

She really was a force in his life. And I remember when I saw her. Actually I saw more of her than him when I did that piece, because he wouldn't see me. It was just a bad time. That assignment I had from *Esquire*, which I never wanted to do; it wasn't my idea. I don't know if you want hear how I got to write that piece, [applause] but it certainly wasn't something I wanted to do.

What it was, I had worked for nine years as a daily reporter for *The New York Times* from 1956, as you said, to 1965. In 1963, people correct me if I'm wrong, but I think there was a three-month strike during that time. During that three-month period, I was on welfare, whatever it was, but what I gained from the strike was three months of freedom. And that meant that I didn't have to go to work five days a week, I didn't have to work for 35 hours a week. I could just do what I wanted to do. And one of the things I did (this is not Sinatra, but it is about journalism in a way that leads to Sinatra), I got an assignment from *Esquire* to interview Peter O'Toole. Pete's a friend of Peter O'Toole as well. And Peter O'Toole had just recently made his tremendous success of *Lawrence*

of Arabia [1962]. I went to see him during the strike, I had an assignment so I could spend two or three weeks with him. And he was the most intelligent, the most interesting, charming man I ever interviewed. Really, the only one I . . .

GT: I don't know how Pete feels about it, but sometimes you get an assignment, and you do it because you have to do it. In O'Toole's case, it was the one time I really enjoyed research. I didn't enjoy it with Sinatra; it was a mess with Sinatra. Most of the people are difficult to deal with and I can't wait until I finish the piece. In the case of O'Toole, no, no. He looked at me once, he was the only interview subject I ever had who asked me about myself. He said, "You're married?" I said, "Yeah, my wife's grandfather came from Ireland." "You have any children?" "No." "Why not?" "Well, I don't have any money." This was 1964, I didn't have a job. I just quit *The New York Times*. No I worked at *The New York Times*. "And you don't have any children?" "No." "Why?" "Because I can't afford them."

GT: "What do you mean you can't afford them? [chuckle] You're just a conservative guy, you don't take risks? You don't take risks?" And I said, "I don't know what to say." And I'm thinking, "Here I am, talking to this tremendously talented, famous person, and he's taking the time and telling me I don't take risks." And I thought, "Well, maybe I don't take risks." And he said, "Where's your wife?" "She's in New York." "Why don't you have her come over?" "Come over?" "Yeah, she can stay with us." You mean to tell me Peter O'Toole is telling me, his wife was the actress named Sian Phillips. "We can call my wife in New York, and she can come over and we can have big . . . " "In his guest room. What incredible generosity this is. Of course I was like "You serious?" "Sure." "Nan," I go,

38

"Peter O'Toole and his wife Sian Phillips said we could come over here, [chuckle] and you can stay. We can have a week to stay with them, at his house in London." She comes over, and in our guest room we conceived our first child, [laughter] Pamela, who was born in 1964. . . So Peter O'Toole was a good, good experience.

[laughter]

GT: Sinatra instead . . . But I'm not known for Peter O'Toole. I love Peter O'Toole. Pete also does, I think . . .

PH: Yeah. Yeah, I liked him a lot.

GT: I didn't love Sinatra. I admired Sinatra. He shaped my life. Unlike Pete's, my experience with Sinatra was miserable. Miserable. [chuckle] And I didn't want to do it. And the reason I had to do it, is because in 1965 we had this one-year-old child, Pamela, born in '64. In '65 I left *The New York Times*, because I loved the freedom I'd gotten during that period of the strike, I mentioned earlier. And I went to *Esquire* and they paid me the same amount of money. I used to make 315 bucks a week at *The New York Times*. It didn't sound like very much but it was pretty good. It wasn't the top but it was pretty good. So *Esquire* said, "We'll give you the same amount of money, and all you have to do is six pieces a year." That's pretty good. I said, "Can I pick the pieces?" "No, you can pick three and we'll pick three." The editor of *Esquire* said, "I'm gonna pick three." His name was Harold Hayes. Big name; Pete knows him. So I wanted to write. When I quit *The New York Times*, I wanted to do one thing: I wanted to write about reporters. I thought the world of journalism was so interesting. And the people never wrote about journalists, or copy-readers, or editors. There was no such thing as

media in the language in those days. Since I was always in the home office with the *Times*, and I got to know all the people, including the other people, Pete Hamill and Tom Wolfe and Jimmy Breslin, of different papers, I thought, "What a great world, what a great world. They don't write about it, but I wanna write about it. I wanna be the chronicler of journalism."

GT: So I went to *Esquire* saying, "I wanna write about this obituary writer, this crazy guy, who writes obituaries, Mr. Bad News." "Okay, well do that." And I did that. "I wanna write about this wonderful managing editor, he's married to Harry Truman's daughter. His name is Clifton Daniel. I wanna write about Harrison Salisbury, this great foreign correspondent . . . Blah blah blah." And they said, "Well, you can't write about that. That's your first piece. You did the obituary. Second piece is our choice, Sinatra." I said, "Come on, Harold Hayes. Harold . . . God he's been done in *Life Magazine*, *Look* magazine, and so many things. He's so famous, you can't write about him. I don't think you can write about famous people, because what can you say to famous people? They don't even know . . . I mean they're so controlling in what they can say. They're so conditioned to the sound bite, or they run the interview." They said, "You have to, it's a cover story. It's easy, it's easy. Just go out there."

GT: The press agent, Jim Mahoney said, "He'll see you Monday. Fly out Sunday. See you Monday, Tuesday . . . Do that. Come back here, do your piece on *The New York Times* guy you wanna do, this Harrison Salisbury, or whoever you wanna write about." So I went out there, and I arrive Sunday night. *Esquire*, like many magazines in those days, gave you an expense account. I don't know what Pete Hamill's experience is, but I know that I had access to a very fine

hotel, the Beverly Wilshire. I rented an Avis car, which I kept in the garage. First, when I arrived there Sunday night, I ordered a steak and a wine in my room. I had a nice suite, Jesus, great. The next morning I called up Jim Mahoney. "Hey Jim, I'm here." "Oh, are you? Yeah, great." "When am I gonna see Mr. Sinatra?" Mahoney says, "I don't know, he's not feeling well." "Oh. What's wrong with him?" "He has a cold." [chuckle]

[laughter]

GT: "It'll take a couple of days, he'll be alright. We'll see him." He said, "Well, it's not only that. He's not feeling very well about your being here." I said, "It was all set up. Harold Hayes told me it was a cover story, and it was all set up, all I had to do was show up." "Well, not really. His lawyer is worried about this goddamn Walter Cronkite. Cronkite, we hear, is doing a CBS show on Sinatra's alleged connection to organized crime figures." And I said, "Listen, I'm not writing about organized crime figures." "Well, Sinatra's lawyer, Mickey Rudin," or whatever his name was . . . Pete, what was his name? Mickey Rudin?

PH: Yeah.

GT: "Mickey Rudin would like to see what you're writing." "Oh, come on, Jim Mahoney, we can't do that. I couldn't do it at *The New York Times*, I can't do it at *Esquire*. We can't, we can't do that." "Well, then maybe you have to go back." I thought, "Well, great. I can go back, I can do what I wanna do. I don't have to do this thing." But I said, "I'm gonna call the editor of *Esquire* and tell him what you told me." So I called Harold Hayes and I said, "Harold, they said they're gonna want to see it and of course we can't do

41

that." And he said, "Well, what do you wanna do?" And I said, "Well, I can come back if you want, or if you want me to I can stay out here and try to see other people." I always thought my strength as a journalist, if I had any at all, was I'm very comfortable with people outside of power. I'm not so comfortable with power, but I'm more comfortable with people, the ordinary kind of people that I grew up with, my hometown and people I knew. And because I was a son of a store keeper . . . When you're a shopkeeper's son, as I am, you get to know customers of all kinds, and because of your parents' training as they do, because . . . Be very polite to customers, after all they're giving us bread. That's how we're living off having good customers. So I learned as a boy to treat customers with great respect and deference, and I was very polite. And I managed to be a good journalist on *The New York Times*, not by front page stories; I hated it, I didn't wanna be on the front page, because the front page is news of important people. But page 37, 38, where I dwelled and wanted to dwell, were stories about ordinary people, a doorman in an apartment building, a guy that fixed bicycles, or some woman that fed pigeons or somebody, it was a charwoman at the Chrysler Building at 5 o'clock in the morning, those odd characters in the shadows of the towering City of New York. I loved those characters. So when I came to Sinatra I knew . . . Because I'd been to Los Angeles before this, this was '65, '66.

GT: I knew some people who ran restaurants, and I knew that they knew people who lived in the entertainment industry when Beverly Hills was the center of it; LA is the center of it. You have musicians, you have former directors, you have ex-girlfriends of Frank Sinatra, you have limousine drivers. It's a celebrity city and I knew people. One guy I knew was the owner of a restaurant called The Daisy, Jack Hanson. He knew about Sinatra, he knew people that worked for

Sinatra, he knew people who dated Sinatra. So from Jack Hanson I got these phone numbers, and I spent the next two or three weeks talking to these ordinary people about Sinatra. Harold Hayes said, "Do stay out there, do that." And after two weeks I got a phone call in the Beverly Wilshire. I was worried about my expense account, because I was running up pretty good bills, taking people to dinner. And I said to Harold, "Do you want me to move to a cheaper hotel?" "No, you stay there." They wouldn't do it today; today they'd say, "Get out of the hotel and live in a car if you want to."

But, I did the piece that way. So the point is I never did know Sinatra, but I knew about Sinatra from people who knew or thought they knew Sinatra. And sometimes, unless you're as lucky as Pete was and have a personal relationship, as I have with Peter O'Toole. I saw O'Toole after I wrote the piece. I saw him one time, I was in PJ Clarke's with O'Toole. It wasn't you, Pete, was it? Were we with O'Toole one night till 4:00 in the morning? There was one time they closed the place. I think you were there.

PH: Yeah. Yeah.

GT: But I could never do that with Sinatra. I would not. Pete did, but I somehow never was lucky enough. But I wrote the piece. When I finished that piece, do you think I thought that was a great piece? No. No, it was another piece. I had a one-year-old daughter, I had to do six pieces because I needed the money. Nan and I were living just barely on what we were earning. And then, I finished that piece, and then I went on to do what I really wanted to do, this piece on a managing editor, named Clifton Daniel, which was a lead piece, three months after Sinatra. And that made me want to write about the newspaper, and I never wrote for *Esquire* after that one year. And then later on, 30 years ago, 40 . . . "Frank Sinatra

Has a Cold. Frank Sinatra Has a Cold. Frank . . . " Jesus, how come that piece that I didn't even like . . . I thought I did much better in other pieces, even for *Esquire*. I don't know, maybe it's just Sinatra that made that piece famous. If I'd written about Peter O'Toole it wasn't that famous. I mean he is famous. I don't know what it is that makes a piece. Can you explain? Did you ever do a piece, Pete, that you thought wasn't your very best? I mean everything is your very best, but sometimes you're measured by . . .

PH: Yeah, but every time I did I quoted to myself Samuel Beckett's famous advice.

GT: What was that?

PH: "Fail better."

[laughter]

GT: Fail better. I don't know.

PH: By the way, if you want to read the piece that Gay's talking about, both pieces, the O'Toole piece and the Sinatra piece, get this book.[8]

GT: Oh boy, listen . . . I'm so glad you came, I'm so glad you showed up.

[laughter]

[8] Gay Talese, *The Gay Talese Reader: Portraits and Encounters* (New York: Bloomsbury, 2003).

PH: It's one of the great collections of American journalism.

[applause]

GT: Oh Pete, so sweet. Well, I'll tell you, in all my years of journalism I have never met a person I respected more than this guy. This guy is a wonderful writer.

[applause]

GT: But I'll tell you what else that Pete Hamill is besides being a novelist, an essayist, a journalist, an editor; he was an editor as you know. He is the most decent man I have ever met. This guy has a sense of humanity and humility and a sense of respect. I've never respected a man more than this guy.

PH: Thank you.

GT: I really do.

PH: Thank you.

[applause]

GT: Now are we running out of time here? We're babbling?

SGP: No, no, we're not running out of time, but I would like to conclude this formal session by quoting two lines from Pete Hamill's book, revealing Frank Sinatra as an existentialist philosopher. You might have thought of Sinatra as many, many things over the past 100 years, but you probably never thought of

him as an existentialist philosopher. Here is a quote from Pete's book towards the end; actually two separate quotes. This is Sinatra speaking in the first person, "Sometimes I think I know what it was all about, and how everything happened, but then, I shake my head and I wonder. Am I remembering what really happened or what other people think happened? Who the hell knows, after a certain point?" [chuckle] I commented on this line in an essay, "Contrary to the cock-sure assertiveness of 'My Way,' Sinatra at the end of his life was less sure of his way than at any time of his life." And a final quote from Pete Hamill, Sinatra speaking late in life: "Maybe that's what it's all about. Maybe all that happens is, you get older and you know less."

[laughter]

It's extraordinary, really, and a sign, I suggest of wisdom.

[applause]

GT: That better not be true of your two guests tonight.

SGP: I don't know. [chuckle] Anyway, what I'd like to do now with the time that we have remaining about 15 minutes is to open it up for questions, comments, from folks in the audience.

GT: Tell them to stand up and we'll repeat the question for those who can't hear. You just give us the question. Stand up though, we want to look at you.

Audience Member #1: What Sinatra songs are the most meaningful to you two?

GT: What Sinatra songs are the most meaningful to the two of us? Pete, what do you think?

PH: "You Make Me Feel So Young."

[laughter]

[music]

PH: That's great.

SGP: We told both of them they had to sing for their supper tonight.

[laughter]

PH: When you hit 80 it becomes your favorite song.

[laughter]

GT: What's the next question? Way back there.

AM #2: Why don't you mention Cookie Lavagetto?

[chuckle]

GT: What's the question?

AM #2: It's not a question.

[laughter]

Remember the tiny boy, Cookie Lavagetto, Brooklyn Dodgers, 1940?

GT: I bet Pete knew him, right?

PH: Well, the odd thing is the Yankees had the corner on most of the great Italian players, not only DiMaggio.

AM #2: He played for the Dodgers in 1940.

PH: Yeah, but we had Carl Furillo.

GT: Crosetti.

PH: And Cookie Lavagetto was not exactly Italian. But you didn't gauge. . . Most of us, growing up in Brooklyn, I understood later, since everybody was either of Irish descent, Italian descent or Jewish descent, there was one black person living in the whole neighborhood, which was not that big, but one. But I began to realize what I didn't formulize until much later, that to be a New Yorker, is to live among people who are not like you.

GT: That's right.

PH: And it's one of the great things about it. It's the most enriching kind of thing, as compared to even places in this country where they insisted everybody has to be like everybody else. "Yeah? Kiss my Irish ass!"

[laughter & applause]

PH: There was an attitude that said, "We know what we're doing. Who's got the spaldeens?" [laughter]

We didn't have a sense that we were earning our way into America, we were born there. And our parents got us there, and our parents didn't hold-up banks, they went to work. That was their favorite four-letter word, W-O-R-K, [chuckle] because the Depression had taught them how rare it could be. So, to this day, there's part of me that thinks of Brooklyn as the Old Country. My Old Country, as Gay would think of New Jersey. And a father who's a tailor, so no accident that he wrote the best-tailored prose of his generation.

[laughter]

GT: Oh boy.

PH: Nobody came close. So, I think we have to look at the world we're in and celebrate it when we're kids. And we did celebrate it. We celebrated it for the rest of our lives.

[applause]

AM #3: Mr. Hamill, in your novel, *North River*,[9] I believe it was, the protagonist goes to a dance floor and he sees a singer. You describe him like it's Sinatra, but you don't say it's Sinatra, but was it Sinatra?

[chuckle]

[9] Pete Hamill, *North River* (Thorndike, ME: Center Point Publishing, 2007).

PH: Yeah, I have a scene in a place that's like Roseland, and my character who's a doctor in the village, and he's going, he has an Italian girlfriend, of course. They go dancing at Roseland, and as a singer who is absolutely based on Sinatra, because Sinatra would every once in awhile in those days, in the Depression, before he got a name, go and try to get a gig here and there in Manhattan, a place he could see from the docks at Hoboken, and he came in one block at a time to find the whole wide world, and one of the blocks was 52nd Street, [chuckle] where Roseland was. But you're right, thanks for reading carefully.

[laughter]

GT: Got another question back there.

AM #4: You know when Sinatra was in the '60s when, before they were big but looked different, different music, and now it's a young group maybe John Lennon, do you know anything about that?

GT: Rephrase the question.

SGP: So the question was the influence of The Beatles and the whole British invasion, how it changed the American music scene.

AM #4: What he thought of it, and was it something that he could relate to, or was some tension between Frank Sinatra and John Lennon?

SGP: I don't know if there was tension between Frank Sinatra and John Lennon, but there was certainly tension between Frank

Sinatra and the British invasion. So these gentlemen can speak to that because they were there.

GT: [gesturing to **PH**] You speak to it.

PH: In my limited sense of what he felt, I think at first he felt threatened, like there was a whole shift, a cosmic shift underway, that made rock and roll the central part of American music rather than Great American Songbook. So I think he felt threatened about it. He would make wise guy remarks here and there, usually of dismissal. But later on I think he got to like some of the music, some of the ballads that were done by The Beatles. And there were other songs. I tried to get him to make a record of "Desperado." I figured an urban version of "Desperado" [laughter] by the Eagles and JD Souther, would've been an amazing record, but he never got around to it. [chuckle]

SGP: I neglected to mention one of our guests. This is a person you might not know, but you have seen his images for the past 40 or 50 years. George Kalinsky is the official photographer of Madison Square Garden and Radio City Music Hall . . .

[applause]

SGP: . . . who created some of the most iconic images of the twentieth century. George, would you like to come up and just speak about your experience working with Frank Sinatra?

George Kalinsky: Thank you. Thank you very much for the great applause, I appreciate that. I must tell you that I admired Sinatra. I knew Sinatra well. I admired him, but I also loved him. I first met

Frank Sinatra in 1971 a few days before the first Ali-Frazier fight, and there was a knock on the door and somebody said, "Frank Sinatra would like to meet you." And he walked into my office, he extended his hand and he said, "Hi, I'm Frank Sinatra. I hear you're a great photographer, and I want you to tell me all you know about photography in five minutes." [laughter]

And we laughed, and three hours later, which included lunch at Patsy's (Patsy's is getting a lot of play tonight) [chuckle] Three hours later I felt that I had met a man that ultimately would become a great friend for the next 30 years.

GT: Did you have any falling out during that time?

PH: During this time you had a long friendship with Frank Sinatra, a very volatile person. We remember him elsewhere. But did you ever have a falling out with Sinatra? Did you ever do anything he got mad at?

GK: I never did anything that he would get mad at. Matter of fact, we used to have some great conversations about art. Sinatra was a person that, whatever he did he wanted to do the best, and that's how we actually met. *LIFE* magazine had hired him to be a photographer for the Ali-Frazier fight, and in order to do that, since he really wasn't a photographer, but he wanted to get the best possible pictures he could, and that's why he came and he contacted me, because whatever he did he wanted to be the best at it. And I remember as our relationship grew, towards 1974, I guess this would be 1973, we went to lunch again, and he said to me that his dream was to be the heavyweight champion of the world, that's what he really would love to be.

[laughter]

GK: But this was not a reality for him. So he said, "The next best thing I can do would be to have a concert at Madison Square Garden, because the greatest event that you can go to would be the heavyweight championship fight at Madison Square Garden." That would be better than any concert, any sporting event, in his mind, to go to Madison Square Garden, and to see a heavyweight championship fight. To him, the aura of that was more than the aura of any other event. So we're sitting in Patsy's and he says that the next best thing is to have a concert in Madison Square Garden, with the atmosphere of a heavyweight championship fight. And he shows me pictures, drawings, of the layout of Madison Square Garden with the boxing ring in the middle, and he said, "This is what my dream is now gonna be, to have a concert at The Garden, and I wanna call it 'The Main Event,' what do you think of that?" And I said, "It sounds pretty good. I have to digest it a little bit. Matter of fact, it sounds very, very good."

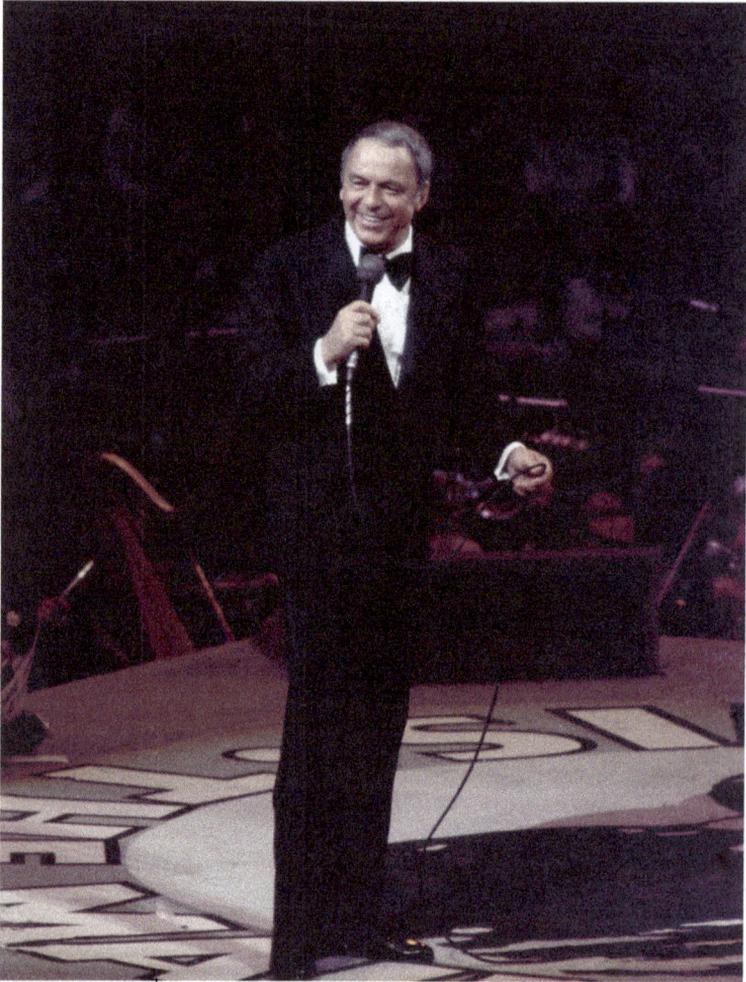

Sinatra performs "The Main Event" at Madison Square Garden,
New York City, October 12, 1974.

Photo: From the Lens of George Kalinsky

GK: He said, "You did a picture for the Ali-Frazier fight that appeared all over. It was a poster, and it was Ali-Frazier, head to head, and it was superimposed onto The Garden ceiling." He said, "Part of my dream would be if I would be in a picture like that," and that came to be. When they came for The Main Event it was internationally televised, and I believe it was one of the first internationally televised entertainment events that there ever was. Sinatra had said, "Instead of Ali-Frazier on The Garden roof, I wanna be in the middle, how can I do that?" And I said, "Frank, you wear a tuxedo, you put boxing gloves on. You go like this . . . [gestures] and I'm gonna photograph you like that and put you on The Garden ceiling." That came about. And that was the ad in every single newspaper in the United States [chuckle] the day of the event. But this was a little background of how this came about. I don't want take away from these great men. I admire these gentlemen so much.

GT: Thank you George.

[applause]

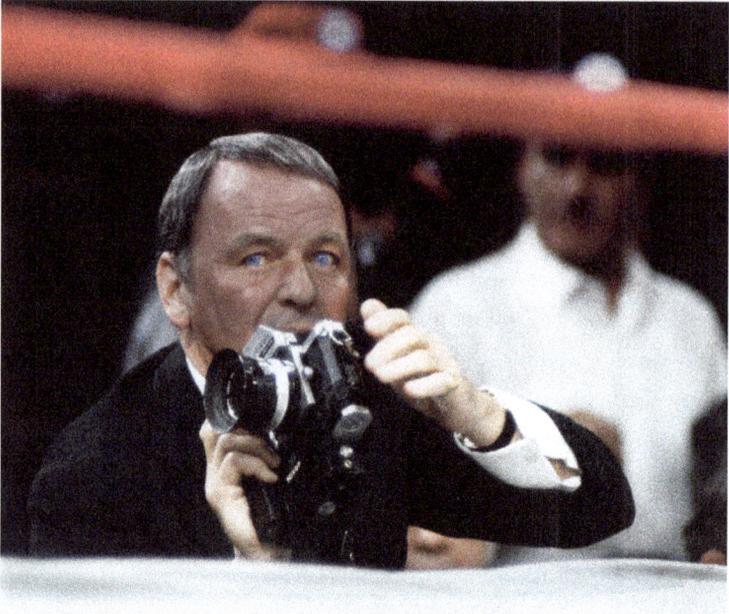

Sinatra takes photos at the Muhammad Ali versus Joe Frazier fight, Madison Square Garden, New York City, March 8, 1971.

Photo: From the Lens of George Kalinsky

GT: One thing you must know about George, he has probably seen more Knick games than anybody in the whole Northeast, which means he gets to skip Purgatory.

[laughter]

GT: He has done his suffering!

[chuckle]

SGP: The cover of our conference program is a photograph of Sinatra at The Main Event by George Kalinsky.

[applause]

GT: Oh, that's great!

GK: Thank you. I really appreciate being here. I must tell you that my grandfather had a tailor shop that was walking distance from here, and I guess it influenced me also in relation to being a photographer, by dressing well. No one though can outdo Gay Talese and how he dresses.

[laughter & applause]

GK: I was born walking distance from here. And so I was raised in Hempstead, Long Island, and I lived here until I was in my 20s. I just wanted to throw that in. So, it's really a pleasure to be here. Thank you.

[applause]

GT: Great job!

SGP: A couple more questions?

AM #5: I read somewhere that eventually Sinatra had come to hate doing "My Way." I don't know whether it's true or not. Would any of you gentlemen like to comment on that?

GT: I didn't hear that, but I know he loathed "Strangers in the Night."

[laughter]

GT: And George told me tonight that he heard a story that in Sinatra's home in Palm Springs that if you push the bell to announce a delivery or something, "Strangers in the Night" would begin to play.

[laughter]

GT: Like maybe that would frighten you off.

[laughter]

GK: That was really true. Actually it was the front door of Sinatra's house, and if you pressed the button, the doorbell, it would play "Strangers in the Night."

[chuckle]

GT: But why did he hate that song? It was mushy, I think.

AM #6: To what extent do you guys feel an artist like Sinatra needs to be aware that they are creating art throughout the process, as opposed to his talent just being the thing? He's a difficult guy, he's a complicated guy and sometimes an artist doesn't necessarily need to be aware that they're creating art, working on art, and he almost seems like he fits that. Is it talent, or is it him being aware that he's creating this kind of thing?

GT: [gesturing toward **PH**] Pete, you answer that.

PH: Is it talent, or is he aware that he's creating something at an ultra-level? Yeah. I think some of it's not art. Remember Sinatra made a record of "Old MacDonald had a Farm" once, because some producer had a contract that made him do it. But I think he understood that you could push the level. And I first understood that in the show that we had here in New York at Lincoln Center about four or five months ago. For the first time I saw some of Sinatra's paintings, and it looked like he had painted music. It wasn't some barely clad woman lying on her elbows or something; it wasn't that. They were abstract. And yet beautifully rendered, in a sense that they were thought out. And I wish somebody would do a book of those paintings,[10] however many there are. So he knew what art was, but I think he also knew that after a certain age it wasn't about fame or about the money, it was about what he would leave behind.

PH: And there were certain things. Gay and I have had editors like this who'd put it into your head. I had an editor who once said to

[10] On the paintings, see Frank Sinatra, *A Man and His Art,* with an Introduction by Tina Sinatra (New York: Random House, 1991).

me, as I was sitting there laboring over an old-fashioned typewriter, he said, "Make sure that if you died in the next half an hour, there's nothing in that typewriter that you'd be thoroughly ashamed of," and then walked away, [chuckle] and some of us did write shameful stuff from time to time in tabloids, particularly. But I think Sinatra did understand what he was doing. He was an intelligent guy. He had read a lot of stuff because he was an insomniac. He wasn't the cartoon figure you met in Hedda Hopper's gossip columns. He was more than that and a lot more interesting. And these new big fat biographies, I hope they make the point and give us further evidence.[11]

AM #7: This question is for Mr. Talese. You were saying earlier that you worked for *The New York Times*. What would be your advice to young writers that are coming up today?

GT: What would I advise young journalists today? I'm gonna ask Pete to also answer that. What I would advise, especially now that technology is such a dominant force in communication, is to try to back away from technology and resist the temptation to do things easily and quickly. So much of what journalism, all forms of journalism, sometimes there's journalism I don't even understand it's journalism. I don't know what a journalist is anymore because there's so many bloggers that are journalists and so many people are communicating on the internet in ways that I don't know if I can define very well. But I really want to say, and let Pete answer more fully, is my experience as a young journalist, when I first started, really as a copy boy in 1953, there was some old reporter, who must have been 70, or a really old guy, still working.

[11] See the Appendix for a select bibliography.

[chuckle]

PH: Young.

GT: Oh, I'm 83 and the guy was old. [chuckle] And he told me, "Young man," he said, "as a reporter, let me give you some advice, stay away from the telephone. Stay away from the telephone." The telephone was the new technology at the time. And what he meant was you have to show up, be there. Don't use the telephone, even if it's a long subway or bus ride or whatever. Go see the person, be there in person. And I have, all my 80 years as a reporter, a journalist, I followed that. I tried to never *not* be there. I don't even know how to use the new technology. I don't even have a cellphone. I don't have any interest in communicating with email. You have to show up. And that's what I think, if there was a young reporter, you or someone, and you want to be a journalist and you want to tell me, "Oh, you can't find jobs." That's not true. When I was young and Pete...

I think I can speak for Pete. But I want him to speak after I just finish, which I will be very surely finish, soon. I think that there is opportunity to be what Pete and I were, and remain, but you have to be very determined to do, to paraphrase Sinatra, "Do it your way." Meaning, you can't be a contrarian. Pete and I respected our editors, and you heard what Pete remembers of an editor giving him some advice, but there's no shortcut to good reporting. There's no shortcut to good writing. It takes time. Just as Sinatra, I think worked on his songs and worked on his songs. He was a perfectionist or almost a perfectionist. And I think Pete and I are out of the old-school that it's never out of style, show up, be fair, get your facts right, and then if you can be lyrical without lying, do it.

61

[laughter]

Pete, What do you think?

PH: Well, I agree. I mean, you have get out of the building. You have go to the place, and if it's on the fourth floor right, you have to go up those stairs and knock on the door, no matter what it is, whether it's the great train robbery in England or some place, or the Lufthansa knock-off or something, or a $6 robbery of an old lady in the hallway, you have go there, because the editor sitting in the office who thinks he or she knows what the story is without getting out of the building is the one that you have to convince. You have to go there and say, "It's better than you think." The real story is almost always better than what the mythological story might be. So all the reporters that I loved, even the columnists, and I wrote columns for a long time, you were by definition going to have opinions, but the opinions were based on the reporting. You had to go out and take a look at these people and get as close as you could in the tight time schedule to the essence of what the story is about. And that story is almost always better if you go and knock on the door.

[applause]

GT: Can we have one last question?

AM #8: My question is for Mr. Talese, but actually before, a quick story. Earlier this year, you actually came to my high school, I went to Frank Sinatra School, in New York City. You came to my journalism class but I didn't get a chance to see you because I was on a field trip with another class, so it's nice to finally see you.

GT: Thank you. What's your question?

AM #8: My question is, did Frank Sinatra ever get back to you? Did he ever read your article and give a response to it?

GT: Did Frank Sinatra read my article, and did he get back to me? No, no he didn't. [chuckle] Let me give you the truth. Sinatra never wrote me, called me. His lawyer didn't call me and say, "You're terrible, we're gonna sue you. It was lousy," or, "It's good," or, "You did okay," none of that, none of that.

GT: At one point, Nan published a very successful poet named Rod McKuen.

Nan Talese: In the 1970s.

GT: Now Rod McKuen, does anyone know who Rod McKuen is?[12] Do you remember? He was a phenomenal seller of poetry, and also, he would sing along. He was a singer as well. And he actually appeared once, or maybe more than once at Carnegie Hall, and this was a very big name, Rod McKuen. And I believe he must have been published by Random House. If he wasn't published by Bennett Cerf of Random House, then he was a friend of Bennett Cerf and his wife Phyllis Cerf. The only reason I know this, is one

[12] Rodney Marvin "Rod" McKuen (April 29, 1933 – January 29, 2015) was an American singer-songwriter, musician and poet. He was one of the best-selling poets in the United States during the late 1960s. Throughout his career, McKuen produced a wide range of recordings, which included popular music, spoken word poetry, film soundtracks and classical music. He earned two Academy Award nominations and one Pulitzer nomination for his music compositions.

time Nan was invited to go to her. Her boss was Bennett Cerf, and we were invited to go to, I think it was White Plains, I think so, their weekend house. And Rod McKuen was the guest of honor, and we were there as were other people. And to my astonishment Frank Sinatra was there. Because Frank Sinatra had a rather varied assortment of friends in various kinds of entertainment. I know that Sinatra's friends at one time or another included Trini Lopez.[13] You know who he is? Alan King, the comedian, was a good friend. One time I remember when the Pittsburgh Steelers had a great, either fullback or halfback, named Frank . . . Franco . . . Pete, what is the guy's name?

SGP: Franco Harris.[14]

PH: I don't know anything about football.

[laughter]

GT: Franco Harris. Alright, Sinatra was a great friend. I mean, Sinatra would have under his umbrella various kinds of talent and he would sort of be in their spotlight for a while and then walk on. He

[13] Trinidad "Trini" López III (born May 15, 1937) is an American singer, guitarist, and actor. His first album included a version of "If I Had a Hammer," which earned him a Golden Disc. Other hits included "Lemon Tree," "I'm Comin' Home, Cindy" and "Sally Was a Good Old Girl." He designed two guitars for the Gibson Guitar Corporation, which are now collectors' items.

[14] Franco Harris (born March 7, 1950) is a former American football fullback who played in the National Football League (NFL) for the Pittsburgh Steelers and Seattle Seahawks. His father was an African American soldier in World War II and his mother was a "war bride" from Italy.

collected those kind of people. So, it was the case with Rod McKuen. And so what I know is that Sinatra was in this private party. It was summertime. Lunch was served under tent on the lawn of the home of the late Bennett Cerf. I don't know if you know who Bennett Cerf was?[15]

GT: But Sinatra never talked to me. Not only did he not talk to me, which was hard to do because it was just a lunch of about 10 or 12 people most. But there was a radio, I remember, on top of a refrigerator in this outdoor area where we're having lunch, and he turned on a ball game. I don't know if it was a Yankee game, or what game it was. But all the time he was listening to a baseball game. Now, that isn't saying that he hated me, but I believe it said he didn't love me very much.

[laughter]

GT: One more question?

AM #9: I've always wondered, when we hear him sing, his phrasing is so perfect, the way he uses English, and yet in his regular everyday speech, he was kind of rough when he's speaking. I've always wondered about that. Now how did he learn that diction that was so perfect, and how did it balance out when he was singing?

[15] Bennett Alfred Cerf (May 25, 1898–August 27, 1971) was an American publisher, one of the founders of American publishing firm Random House. Cerf was also known for his own compilations of jokes and puns, for regular personal appearances lecturing across the United States, and for his television appearances in the panel game show *What's My Line?*

GT: Well, Pete could probably answer that. Well, how come he spoke one way but his diction was so wonderful when singing?

PH: Because he worked at it.

GT: He worked at it.

PH: He worked at it. He didn't want to sound like a cavoon.[16]

[laughter]

PH: That's Irish for schmuck.

[laughter]

PH: And his diction was absurdly accurate. When I was a kid, I would listen to it when I was 10 or 12, and say, "Oh, that's how I'm supposed to say that word." José Serrano, the Puerto Rican congressman,[17] told me one day that he learned how to really say English words with clarity and precision from listening to Sinatra. So, I think that still is useful. Anybody who wants to just use it for that and forget about the way he'd talk to Dean Martin, [laughter] put it aside. He might have been looking for a cheap laugh, the way some of the stuff was. But when he talked to me, he spoke very clearly.

SGP: This gentleman, last question.

[16] Italian American dialect for "cafone"; lit. a peasant but very derogatory.
[17] Congressman Serrano (D) has represented New York's 15 congressional district in the House of Representatives since 1990.

AM #10: Yes, it is also a question for Mr. Talese regarding the *Esquire* piece. I just want to know if you had any other recollections of the recording session

GT: I was able in the presence of my minder who was the press agent of Sinatra, Jim Mahoney, I was able to observe. Well, sometimes as a reporter, especially if it's a superstar, you just observe and you get more than if you talk to them. I observed him in three situations, one was at the prize fight. I happened to be in Las Vegas to watch Floyd Patterson be annihilated, I think by Muhammad Ali. I think it's Muhammad Ali in '66, is that right? [November 22, 1965] And then I saw Sinatra at Burbank, the NBC studio, rehearsing for what would be an NBC special called "Frank Sinatra: The Man and His Music." The third time I saw him, I saw him from a distance in a movie called . . . A movie with Virna Lisi, "Assault on a Queen." And then the most important time I saw him was in a supper club in Beverly Hills called The Daisy. I saw him drinking with these two women at a bar. I was in the other side of the supper club having dinner with Sally Hanson, the wife of the owner. Then I later saw him, I followed him into the pool room, we had this confrontation with this young guy at a pool table. And, that's all.

Anyway, what a good time we had. Thank you.

[applause]

PH: Thank you. Thank you.

GT: Thank you all. Just terrific.

SGP: Thank you all, and most importantly, thank you two legendary American writers.

[applause]

Gay Talese, George Kalinsky and Pete Hamill (signing a copy of
Why Sinatra Matters) at Hofstra University.

SELECT BIBLIOGRAPHY

Clarke, Donald. *All or Nothing At All: A Life of Frank Sinatra*. New York: Fromm International, 1997.

Friedwald, Will. *Sinatra! The Song is You: A Singer's Art*. New York; Da Capo Press, 1997.

Fuchs, Jeanne and Ruth Prigozy, eds. *Frank Sinatra: The Man, The Music, the Legend*. Rochester: Rochester University Press, 2007.

Granata, Charles. *Sessions With Sinatra: Frank Sinatra and the Art of Recording*. Chicago: Chicago Review Press, 2003.

Hamill, Pete. *Why Sinatra Matters*. New York: Little, Brown, 1998/2015.

Holder, Deborah. *Completely Frank: The Life of Frank Sinatra*. London: Bloomsbury, 1995.

Kaplan, James. *Sinatra: The Chairman*. New York: Doubleday, 2015.

_____. *Frank: The Voice*. New York: Random House, 2010.

Lahr, John. *Sinatra: The Artist and the Man*. New York: Random House, 1997.

Lehman, David. *Sinatra's Century: One Hundred Notes on the Man and His World*. New York: Harper, 2015.

Mustazza, Leonard, ed. *Sinatra: An Annotated Bibliography*. Westport, CT: Greenwood Press, 1999.

_____. *Ol' Blue Eyes: A Frank Sinatra Encyclopedia*. Westport, CT: Greenwood Press, 1998.

Petkov, Steven and Leonard Mustazza, eds. *The Frank Sinatra Reader*. New York: Oxford University Press, 1995.

Pignone, Charles. *Sinatra 100: The Official Centenary Book*. With Tina Sinatra, Nancy Sinatra, Frank Sinatra, Jr., Tony Bennett and Steve Wynn. New York: Thames and Hudson, 2015.

_____. *The Sinatra Treasures: Intimate Photos, Mementos and Music From the Sinatra Family Collection.* Forewords by Frank Sinatra, Jr. and Quincy Jones. New York: Bullfinch, 2004.

Pugliese, Stanislao G., ed. *Frank Sinatra: History, Identity and Italian American Culture.* New York: Palgrave Macmillan, 2004.

Sinatra, Barbara. *Lady Blue Eyes: My Life With Frank.* New York: Three Rivers Press, 2012.

Sinatra, Nancy. *Frank Sinatra: An American Legend.* Santa Monica, CA: General Publishing Group, 1995.

Sinatra, Tina. *My Father's Daughter: A Memoir.* New York: Simon & Schuster, 2015.

Talese, Gay. "Frank Sinatra Has a Cold," *Esquire*, April 1966.

Wills, David. *The Cinematic Legacy of Frank Sinatra.* New York: St. Martin's Press, 2016.

Zehme, Bill. *The Way You Wear Your Hat: Frank Sinatra and the Lost Art of Livin'.* New York: Harper, 1997.

Index of Names

VIA FOLIOS

A refereed book series dedicated to the culture of Italians and Italian Americans.

TONY ARDIZZONE. *The Arab's Ox*. Vol. 125. Novel.

PHYLLIS CAPELLO. *Packs Small Plays Big*. Vol. 124. Poetry.

FRED GARDAPHÉ. *Read 'em and Reap*. Vol. 123. Criticism. $22

JOSEPH A. AMATO. *Diagnostics*. Vol 122. Literature. $12.

DENNIS BARONE. *Second Thoughts*. Vol 121. Poetry. $10

OLIVIA K. CERRONE. *The Hunger Saint*. Vol 120. Novella. $12

GARIBLADI M. LAPOLLA. *Miss Rollins in Love*. Vol 119. Novel. $24

JOSEPH TUSIANI. *A Clarion Call*. Vol 118. Poetry. $16

JOSEPH A. AMATO. *My Three Sicilies*. Vol 117. Poetry & Prose. $17

MARGHERITA COSTA. *Voice of a Virtuosa and Coutesan*. Vol 116. Poetry. $24

NICOLE SANTALUCIA. *Because I Did Not Die*. Vol 115. Poetry. $12

MARK CIABATTARI. *Preludes to History*. Vol 114. Poetry. $12

HELEN BAROLINI. *Visits*. Vol 113. Novel. $22

ERNESTO LIVORNI. *The Fathers' America*. Vol 112. Poetry. $14

MARIO B. MIGNONE. *The Story of My People*. Vol 111. Non-fiction. $17

GEORGE GUIDA. *The Sleeping Gulf*. Vol 110. Poetry. $14

JOEY NICOLETTI. *Reverse Graffiti*. Vol 109. Poetry. $14

GIOSE RIMANELLI. *Il mestiere del furbo*. Vol 108. Criticism. $20

LEWIS TURCO. *The Hero Enkidu*. Vol 107. Poetry. $14

AL TACCONELLI. *Perhaps Fly*. Vol 106. Poetry. $14

RACHEL GUIDO DEVRIES. *A Woman Unknown in Her Bones*. Vol 105. Poetry. $11

BERNARD BRUNO. *A Tear and a Tear in My Heart*. Vol 104. Non-fiction. $20

FELIX STEFANILE. *Songs of the Sparrow*. Vol 103. Poetry. $30

FRANK POLIZZI. *A New Life with Bianca*. Vol 102. Poetry. $10

GIL FAGIANI. *Stone Walls*. Vol 101. Poetry. $14

LOUISE DESALVO. *Casting Off.* Vol 100. Fiction. $22

MARY JO BONA. *I Stop Waiting for You.* Vol 99. Poetry. $12

RACHEL GUIDO DEVRIES. *Stati zitt, Josie.* Vol 98. Children's Literature. $8

GRACE CAVALIERI. *The Mandate of Heaven.* Vol 97. Poetry. $14

MARISA FRASCA. *Via incanto.* Vol 96. Poetry. $12

DOUGLAS GLADSTONE. *Carving a Niche for Himself.* Vol 95. History. $12

MARIA TERRONE. *Eye to Eye.* Vol 94. Poetry. $14

CONSTANCE SANCETTA. *Here in Cerchio.* Vol 93. Local History. $15

MARIA MAZZIOTTI GILLAN. *Ancestors' Song.* Vol 92. Poetry. $14

MICHAEL PARENTI. *Waiting for Yesterday: Pages from a Street Kid's Life.* Vol 90. Memoir. $15

ANNIE LANZILOTTO. *Schistsong.* Vol 89. Poetry. $15

EMANUEL DI PASQUALE. *Love Lines.* Vol 88. Poetry. $10

CAROSONE & LOGIUDICE. *Our Naked Lives.* Vol 87. Essays. $15

JAMES PERICONI. *Strangers in a Strange Land: A Survey of Italian-Language American Books.*Vol 86. Book History. $24

DANIELA GIOSEFFI. *Escaping La Vita Della Cucina.* Vol 85. Essays. $22

MARIA FAMÀ. *Mystics in the Family.* Vol 84. Poetry. $10

ROSSANA DEL ZIO. *From Bread and Tomatoes to Zuppa di Pesce "Ciambotto".*Vol. 83. $15

LORENZO DELBOCA. *Polentoni.* Vol 82. Italian Studies. $15

SAMUEL GHELLI. *A Reference Grammar.* Vol 81. Italian Language. $36

ROSS TALARICO. *Sled Run.* Vol 80. Fiction. $15

FRED MISURELLA. *Only Sons.* Vol 79. Fiction. $14

FRANK LENTRICCHIA. *The Portable Lentricchia.* Vol 78. Fiction. $16

RICHARD VETERE. *The Other Colors in a Snow Storm.* Vol 77. Poetry. $10

GARIBALDI LAPOLLA. *Fire in the Flesh.* Vol 76 Fiction & Criticism. $25

GEORGE GUIDA. *The Pope Stories.* Vol 75 Prose. $15

ROBERT VISCUSI. *Ellis Island.* Vol 74. Poetry. $28

EMANUEL DI PASQUALE. *Writing Anew*. Vol 46. Poetry. $15

MARIA FAMÀ. *Looking For Cover*. Vol 45. Poetry. $12

ANTHONY VALERIO. *Toni Cade Bambara's One Sicilian Night*. Vol 44. Poetry. $10

EMANUEL CARNEVALI. *Furnished Rooms*. Vol 43. Poetry. $14

BRENT ADKINS. et al., Ed. *Shifting Borders. Negotiating Places*. Vol 42. Conference. $18

GEORGE GUIDA. *Low Italian*. Vol 41. Poetry. $11

GARDAPHÈ, GIORDANO, TAMBURRI. *Introducing Italian Americana*. Vol 40. Italian/American Studies. $10

DANIELA GIOSEFFI. *Blood Autumn/Autunno di sangue*. Vol 39. Poetry. $15/$25

FRED MISURELLA. *Lies to Live By*. Vol 38. Stories. $15

STEVEN BELLUSCIO. *Constructing a Bibliography*. Vol 37. Italian Americana. $15

ANTHONY JULIAN TAMBURRI, Ed. *Italian Cultural Studies 2002*. Vol 36. Essays. $18

BEA TUSIANI. *con amore*. Vol 35. Memoir. $19

FLAVIA BRIZIO-SKOV, Ed. *Reconstructing Societies in the Aftermath of War*. Vol 34. History. $30

TAMBURRI. et al., Eds. *Italian Cultural Studies 2001*. Vol 33. Essays. $18

ELIZABETH G. MESSINA, Ed. *In Our Own Voices*. Vol 32. Italian/American Studies. $25

STANISLAO G. PUGLIESE. *Desperate Inscriptions*. Vol 31. History. $12

HOSTERT & TAMBURRI, Eds. *Screening Ethnicity*. Vol 30. Italian/American Culture. $25

G. PARATI & B. LAWTON, Eds. *Italian Cultural Studies*. Vol 29. Essays. $18

HELEN BAROLINI. *More Italian Hours*. Vol 28. Fiction. $16

FRANCO NASI, Ed. *Intorno alla Via Emilia*. Vol 27. Culture. $16

ARTHUR L. CLEMENTS. *The Book of Madness & Love*. Vol 26. Poetry. $10

JOHN CASEY, et al. *Imagining Humanity*. Vol 25. Interdisciplinary Studies. $18

www.ingramcontent.com/pod-product-compliance
Lightning Source LLC
Chambersburg PA
CBHW072046040426
42447CB00012BB/3036